Fantasy World

GRAYSCALE PHOTO COLORING BOOK FOR ADULTS

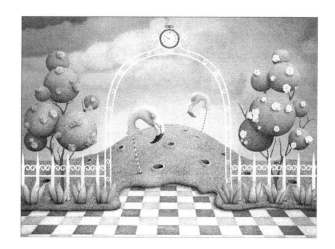

Majestic **COLORING**

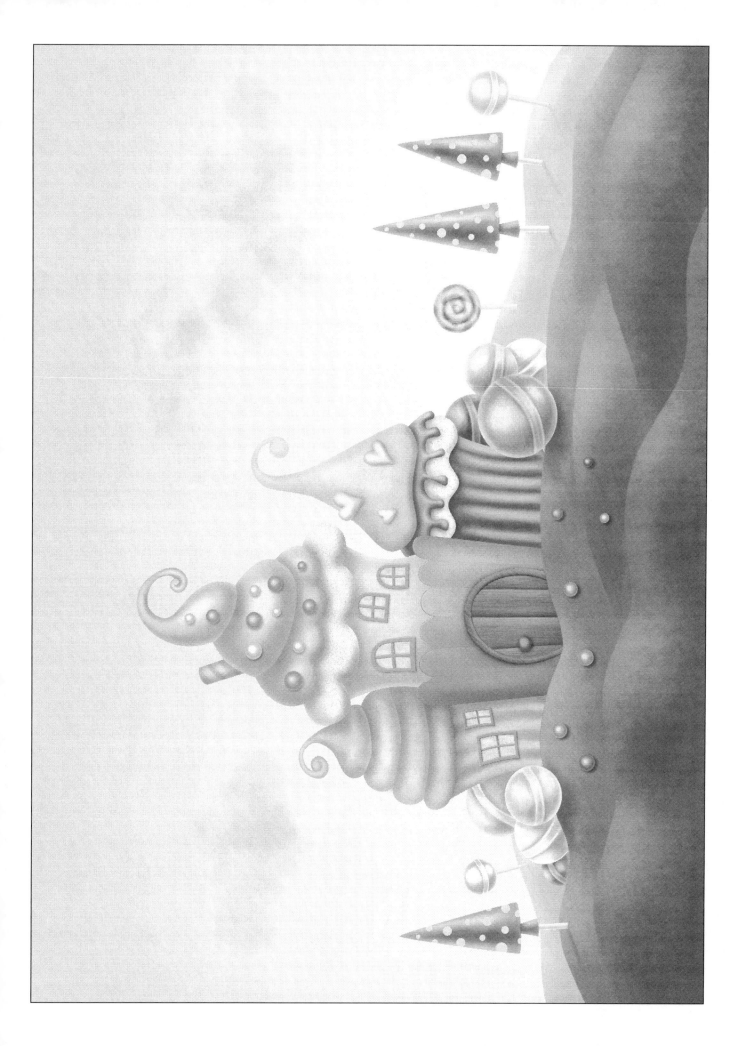

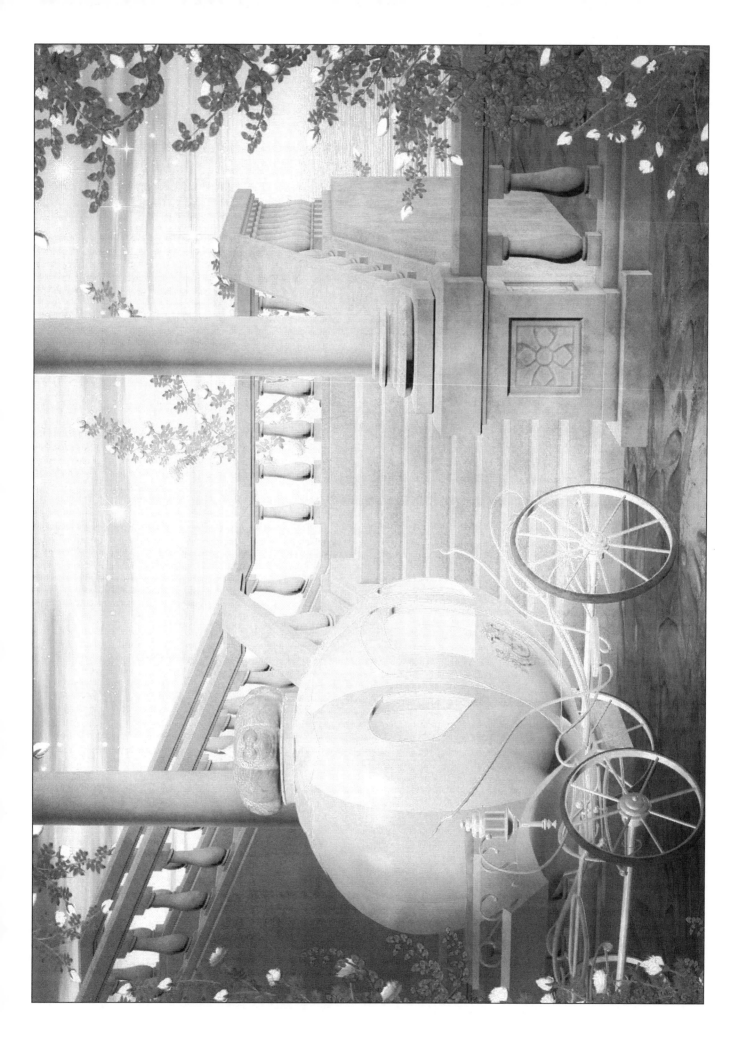

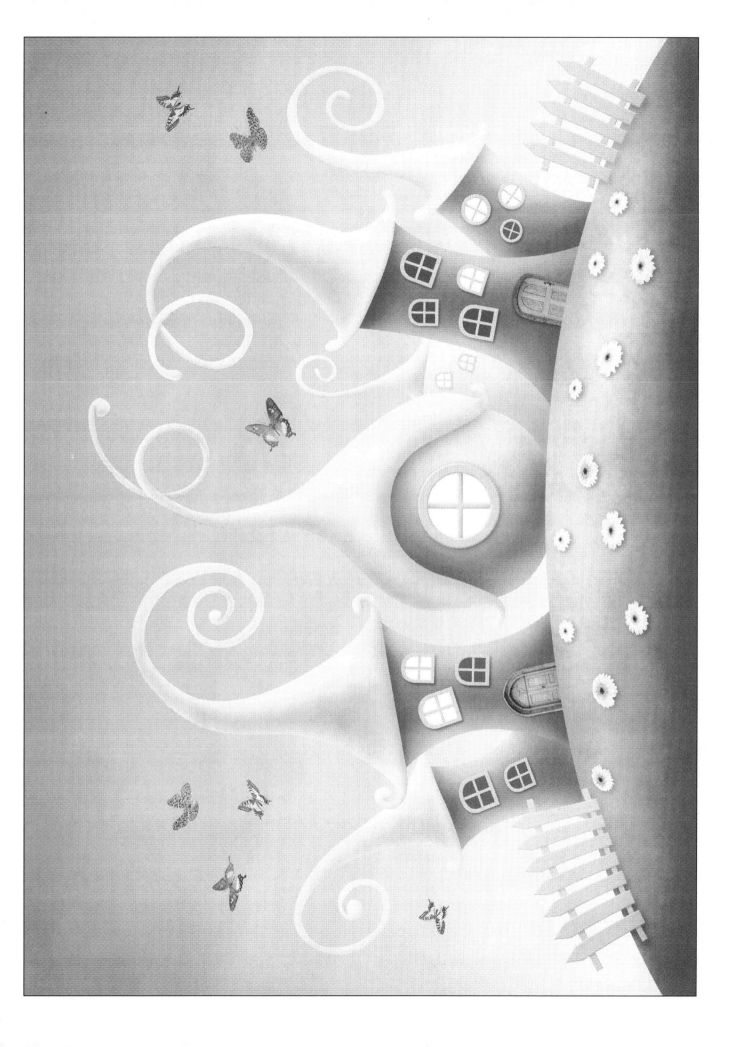

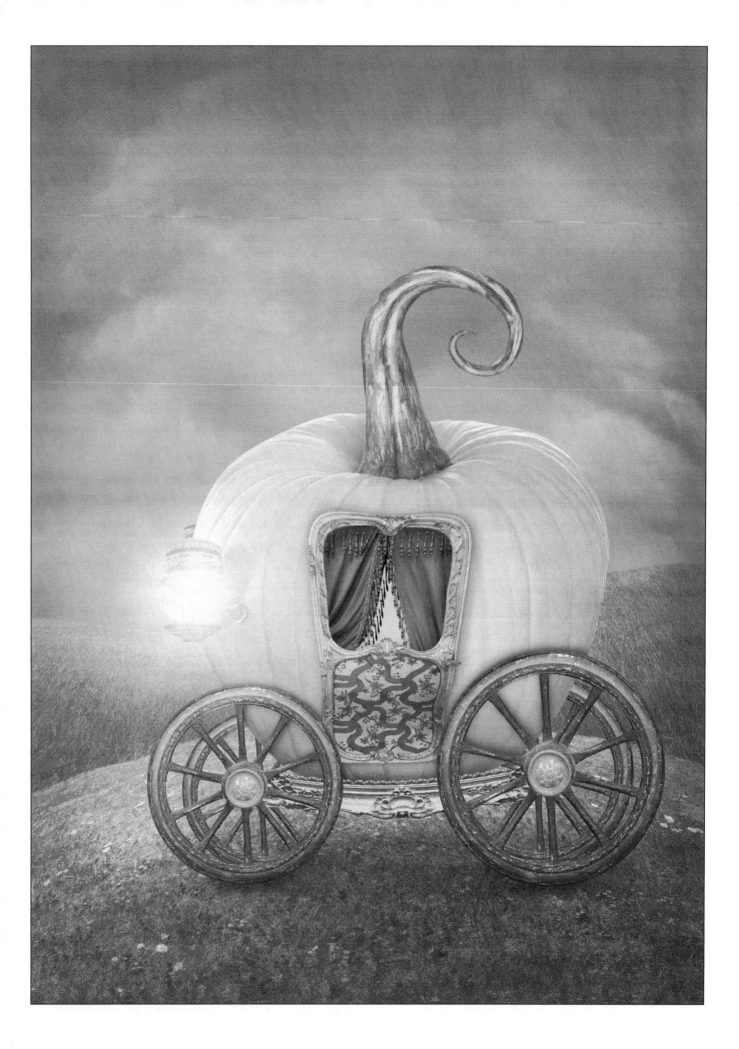

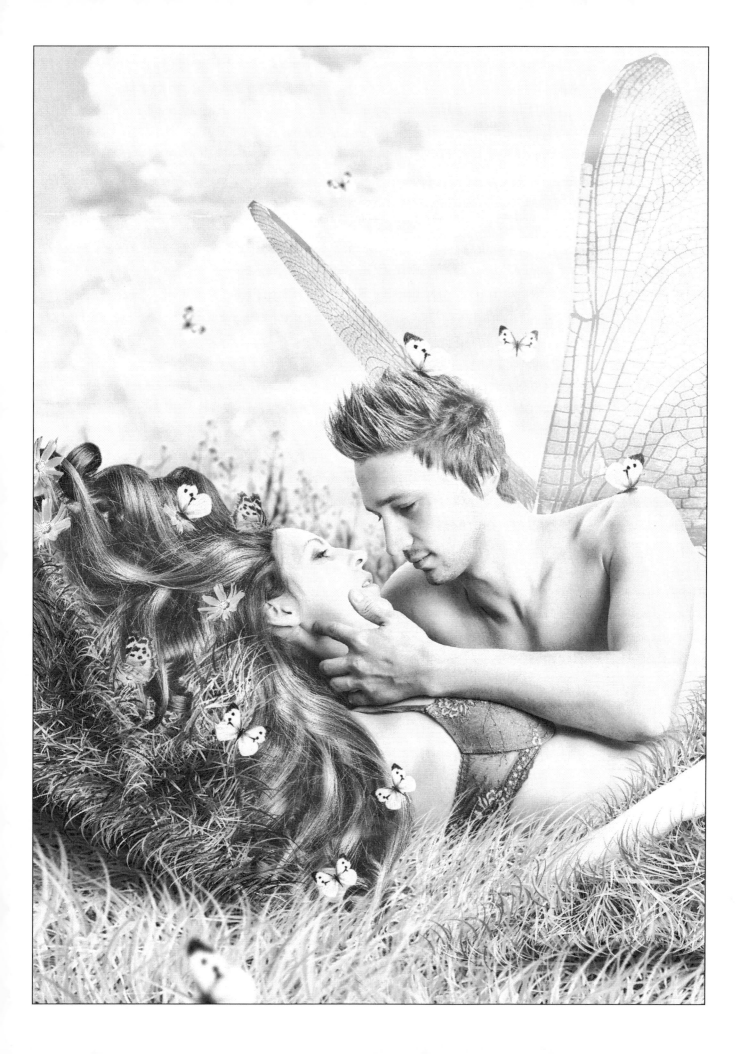

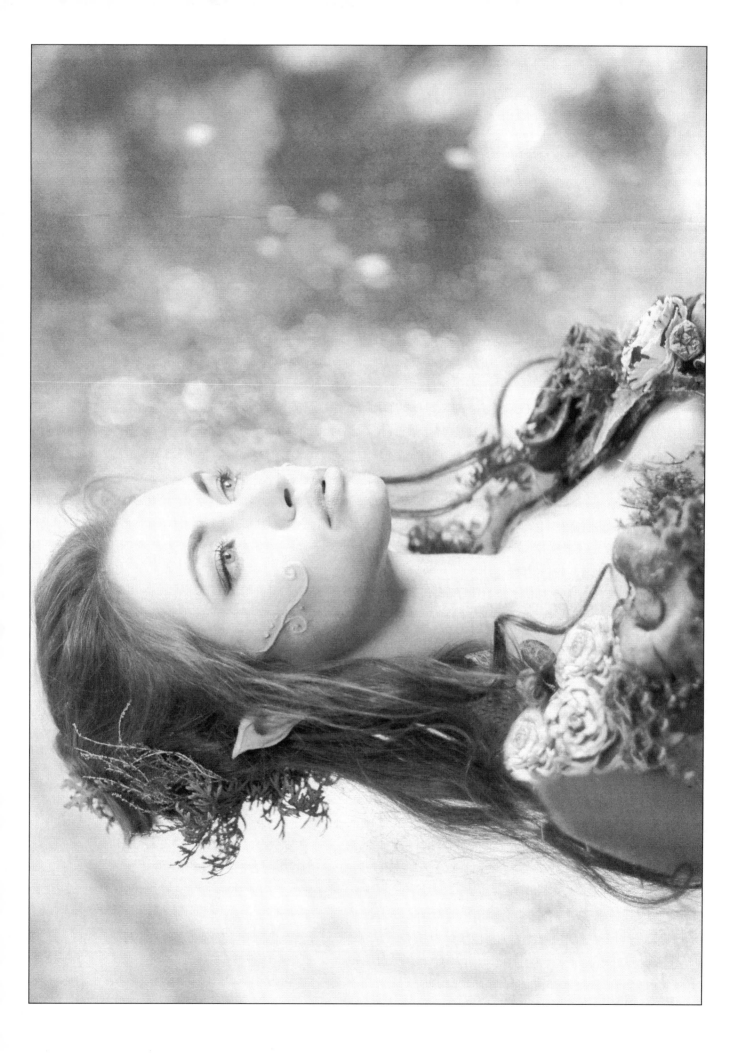

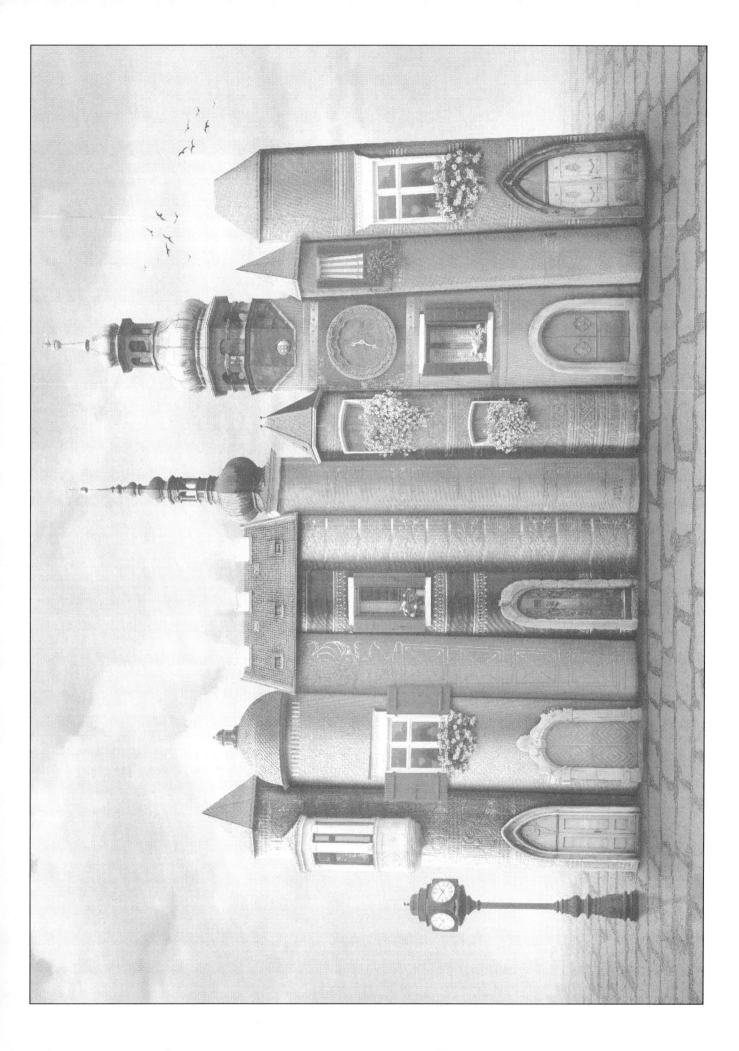

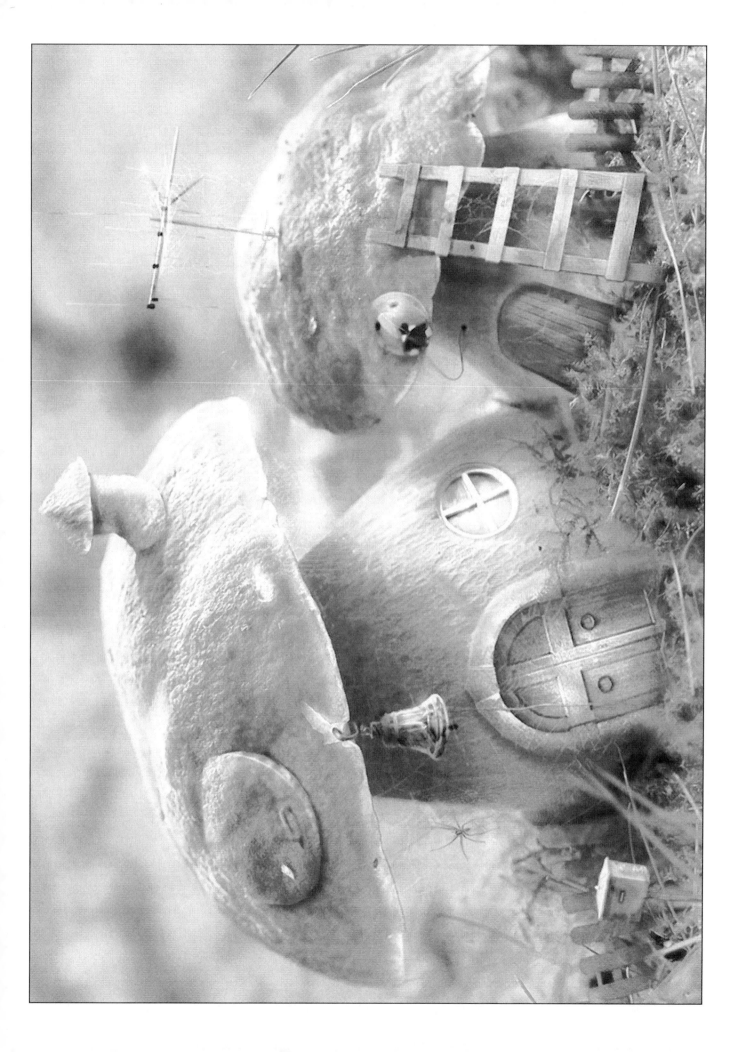

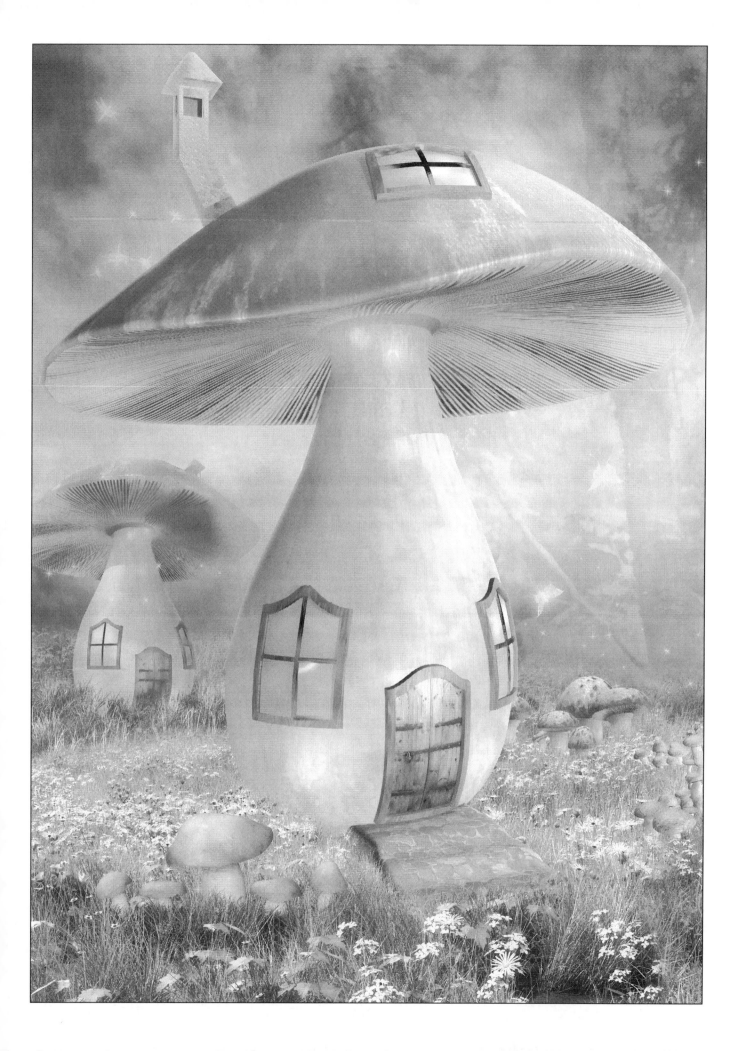

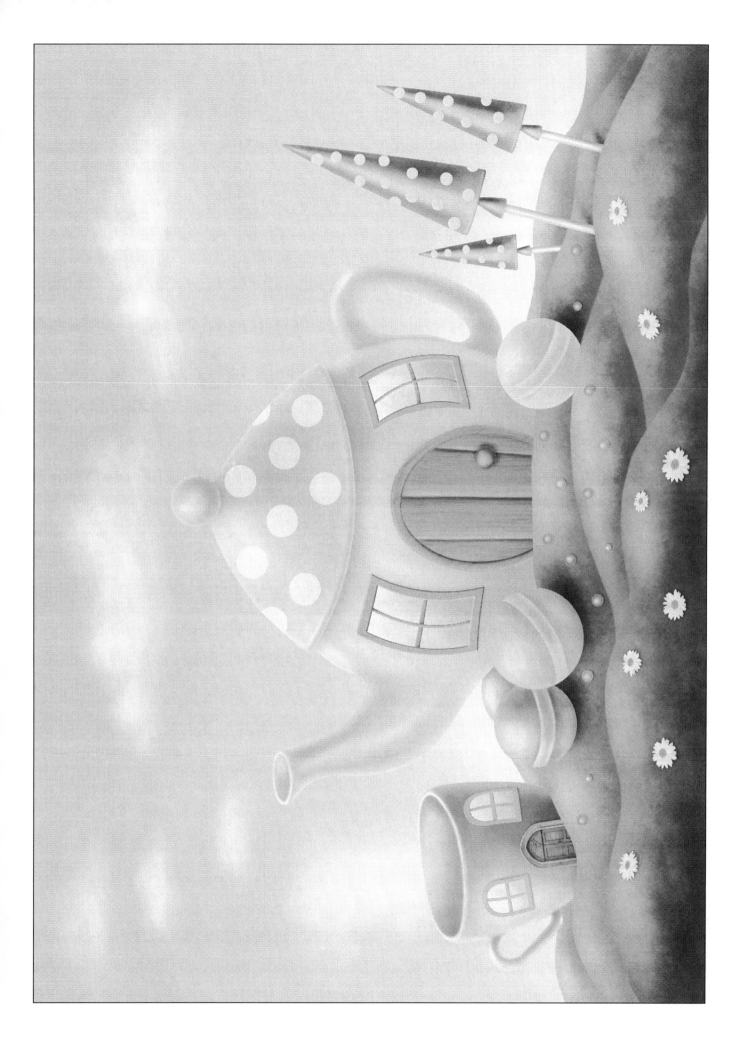

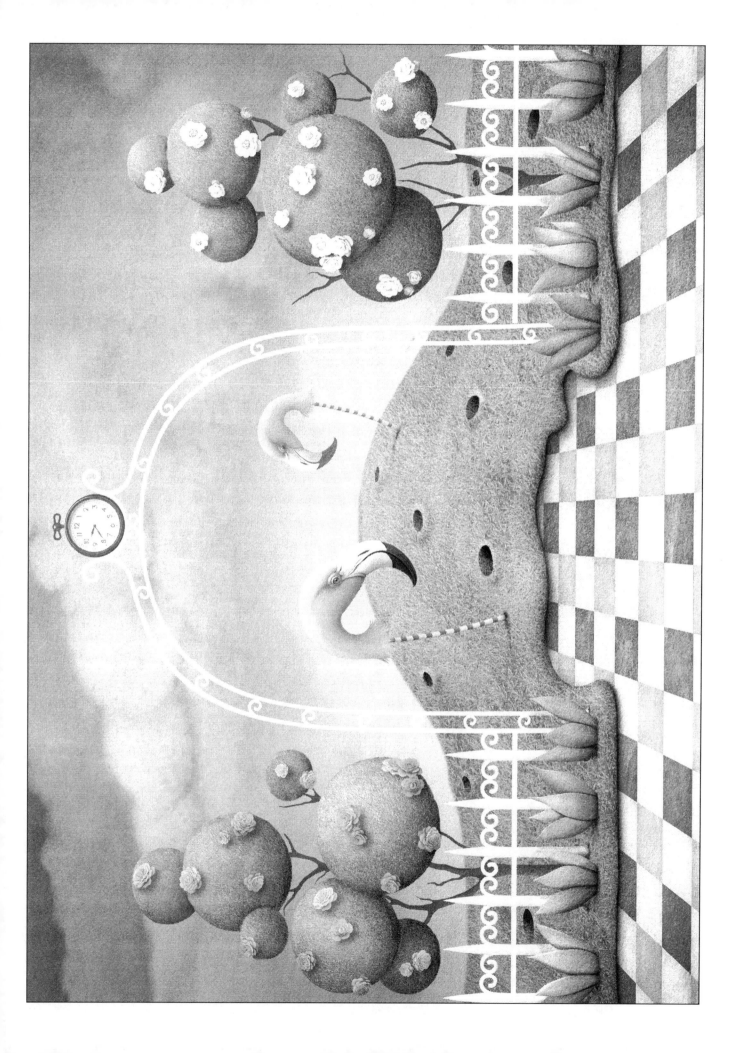

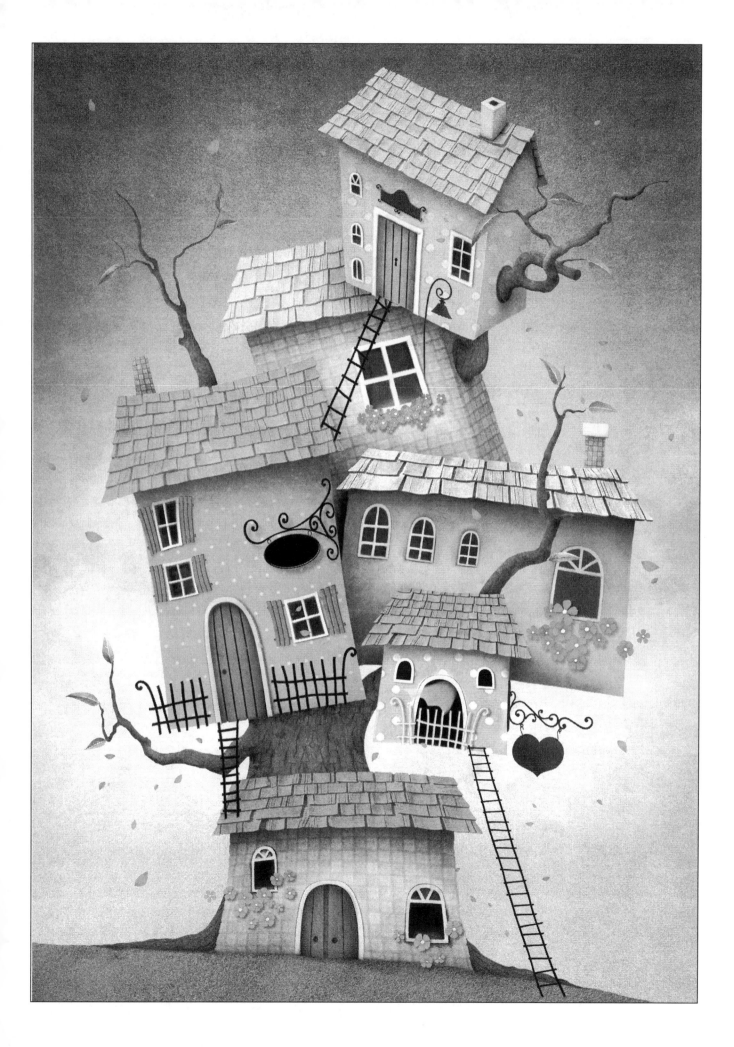

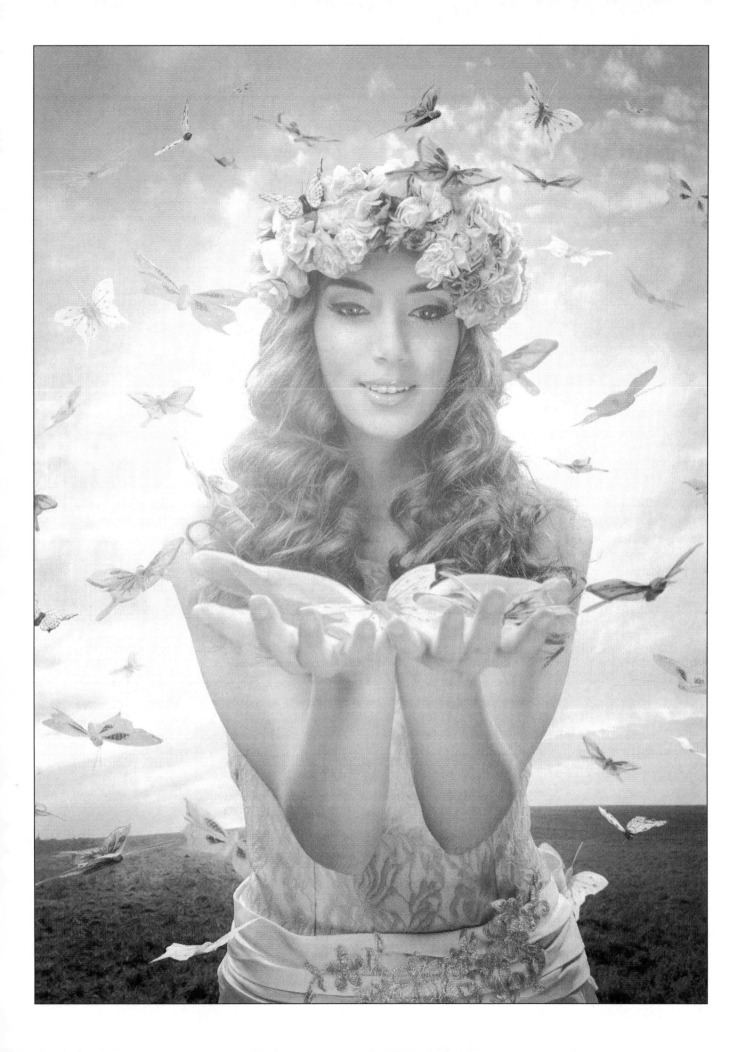

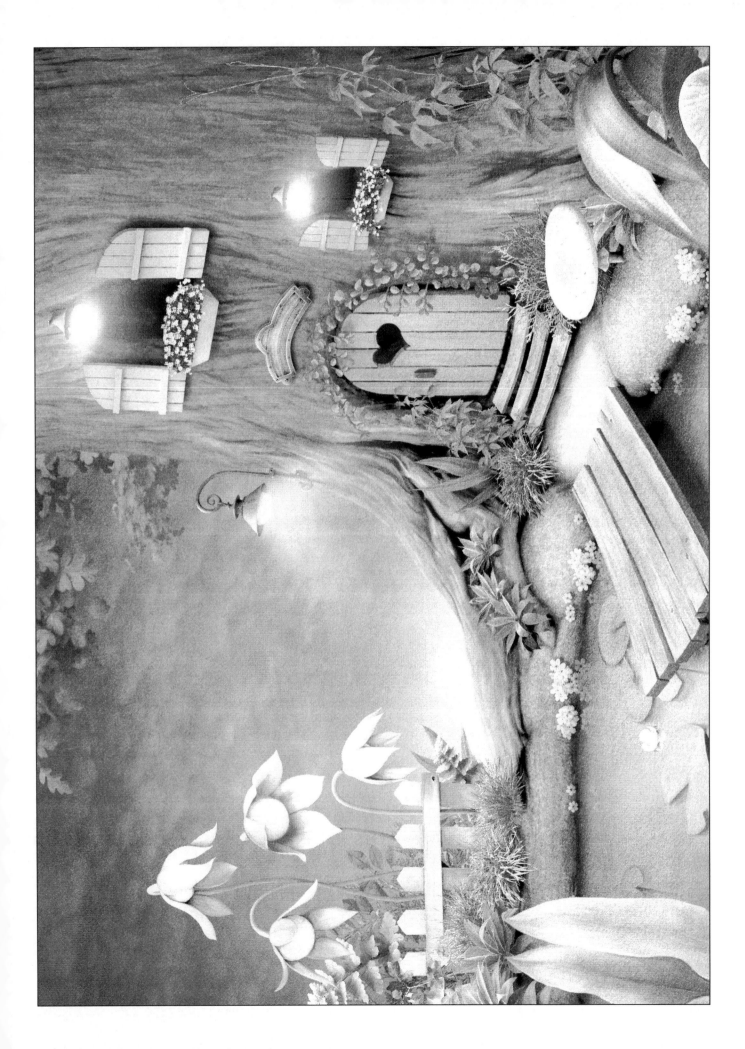

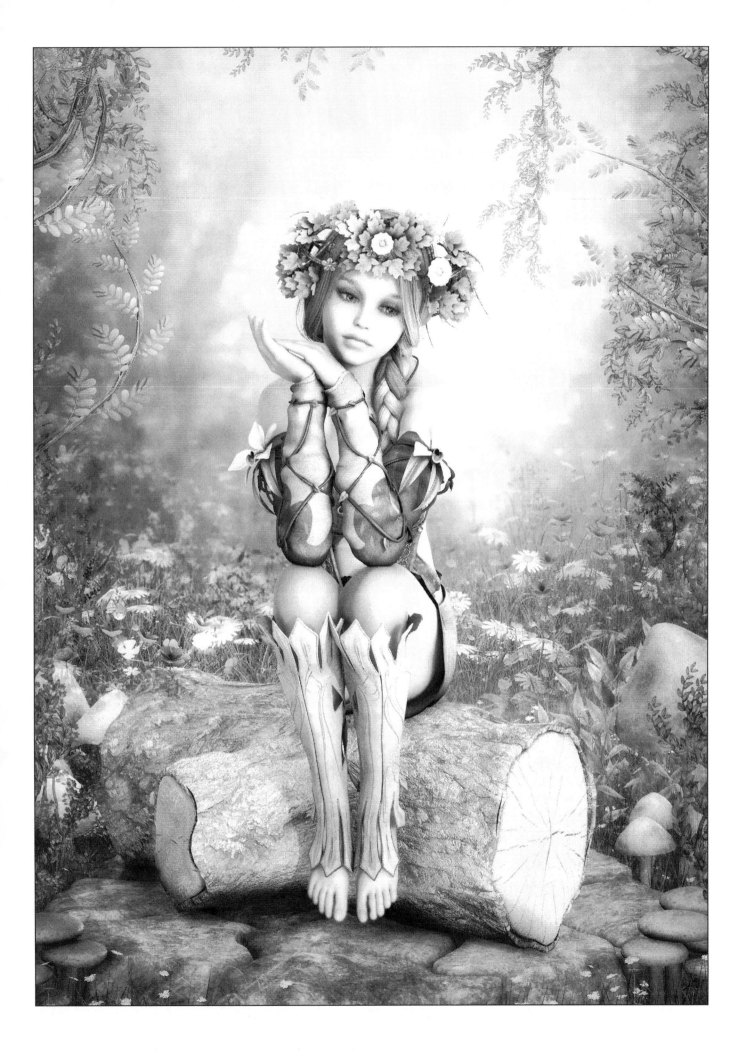

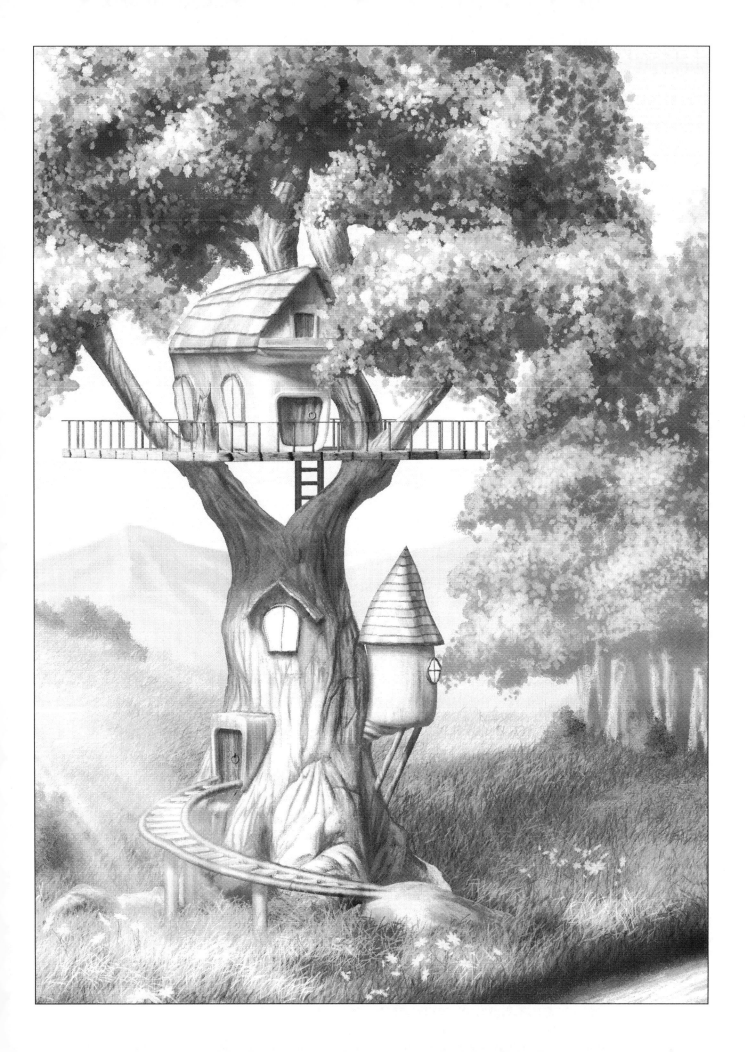

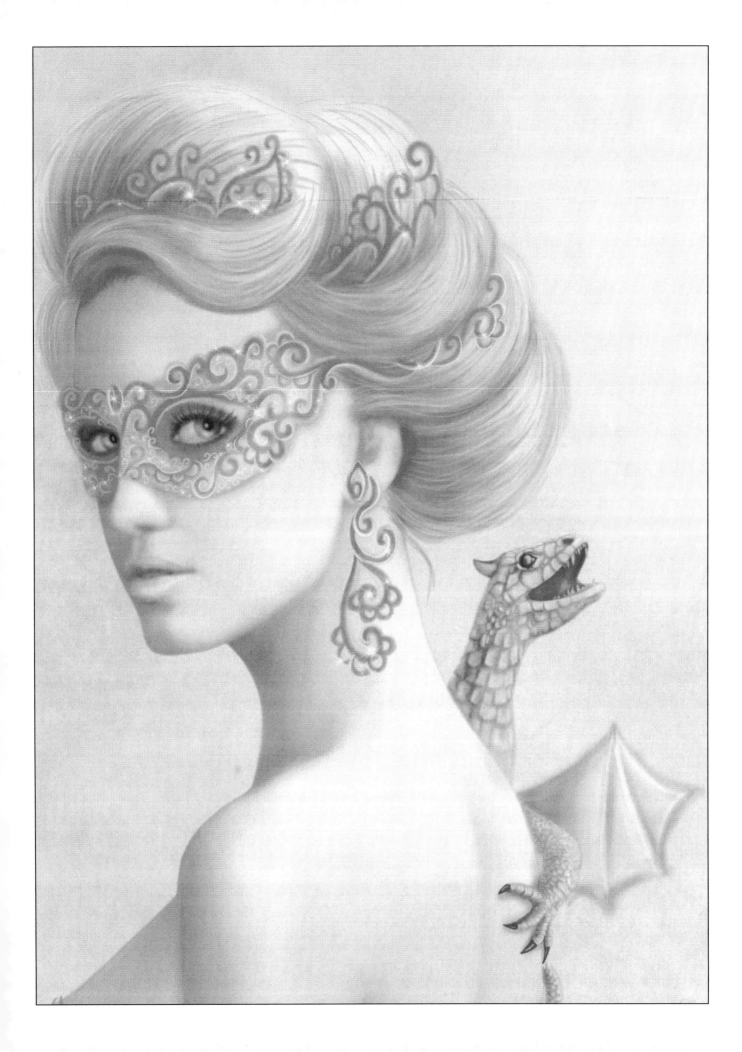

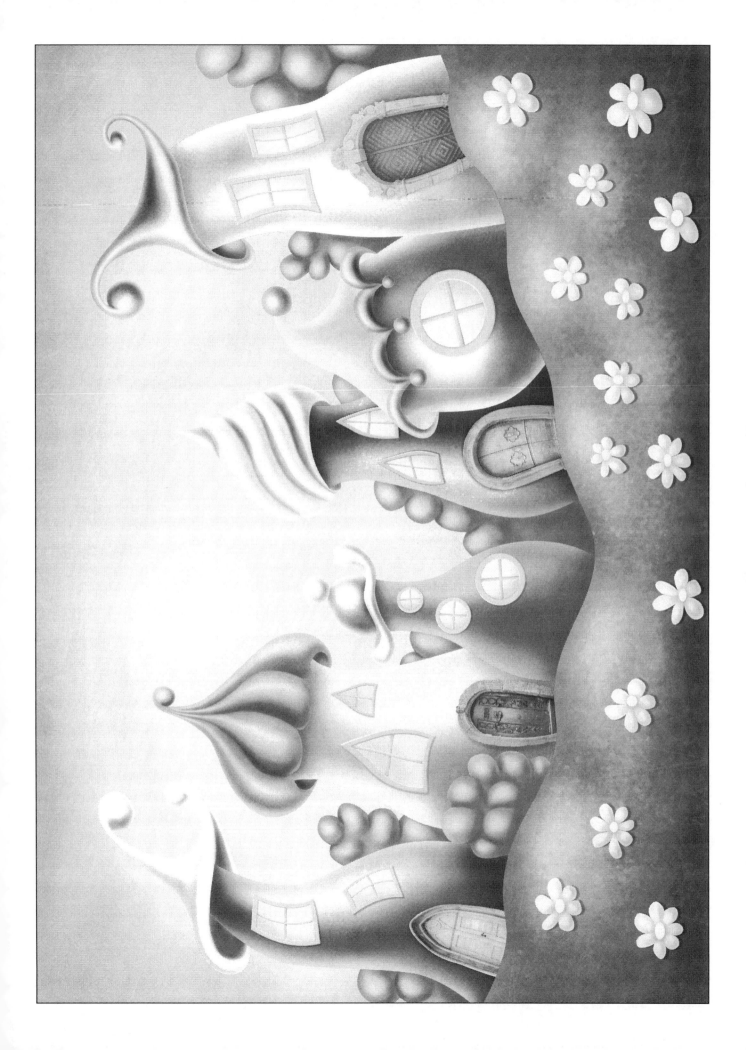

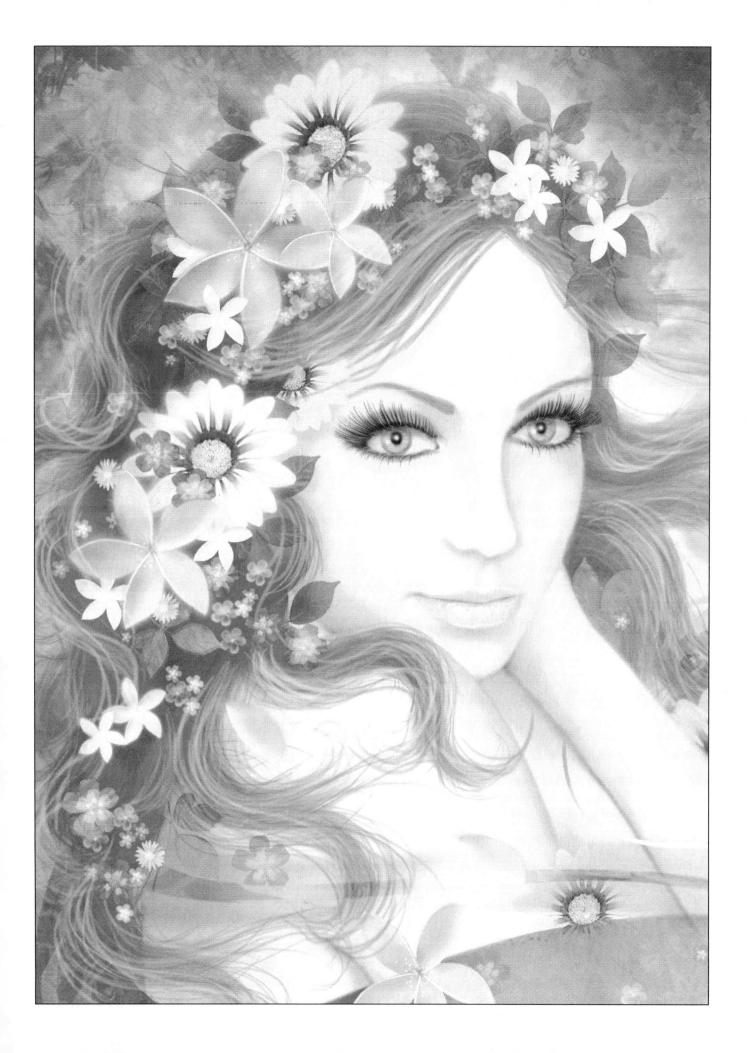

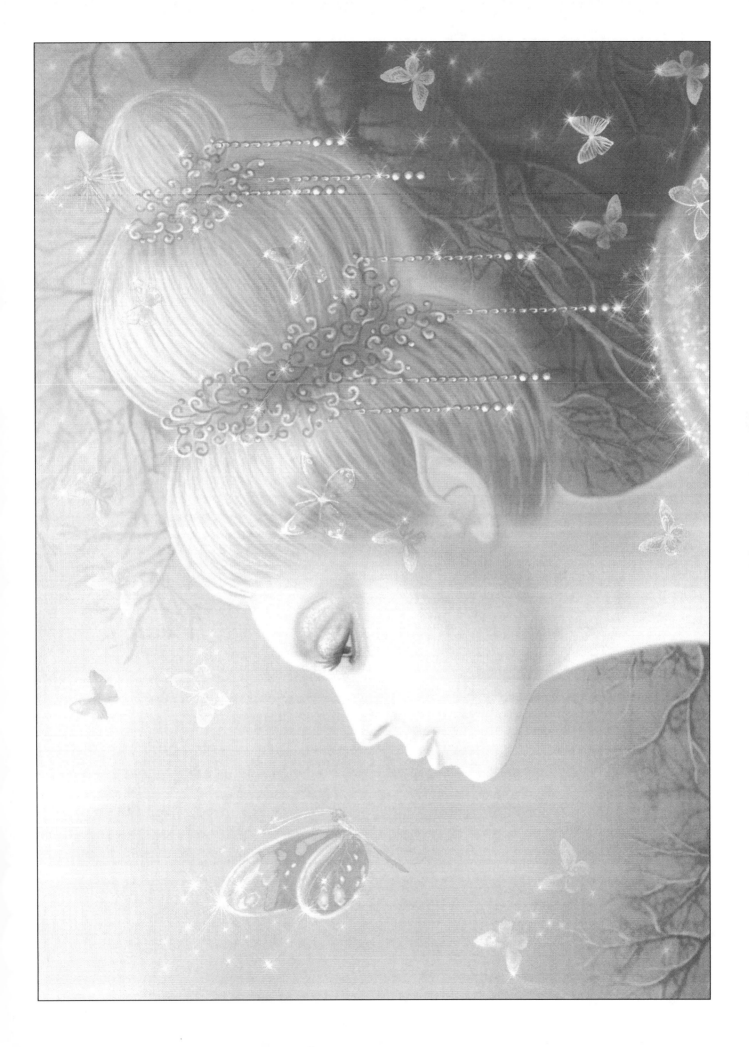

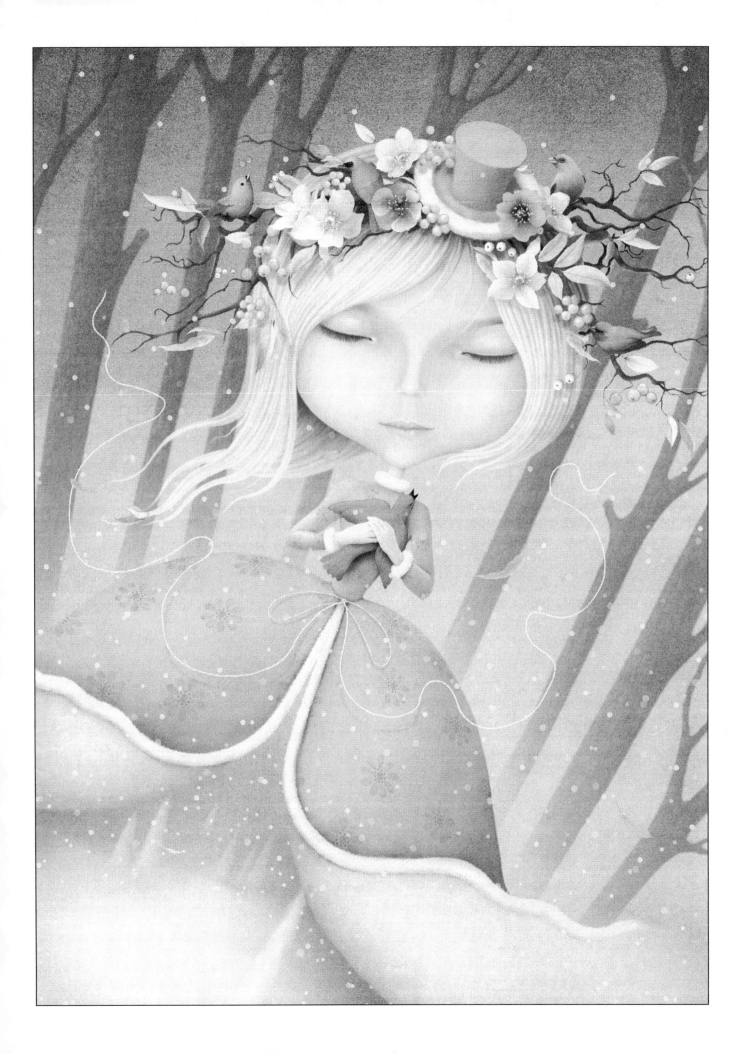

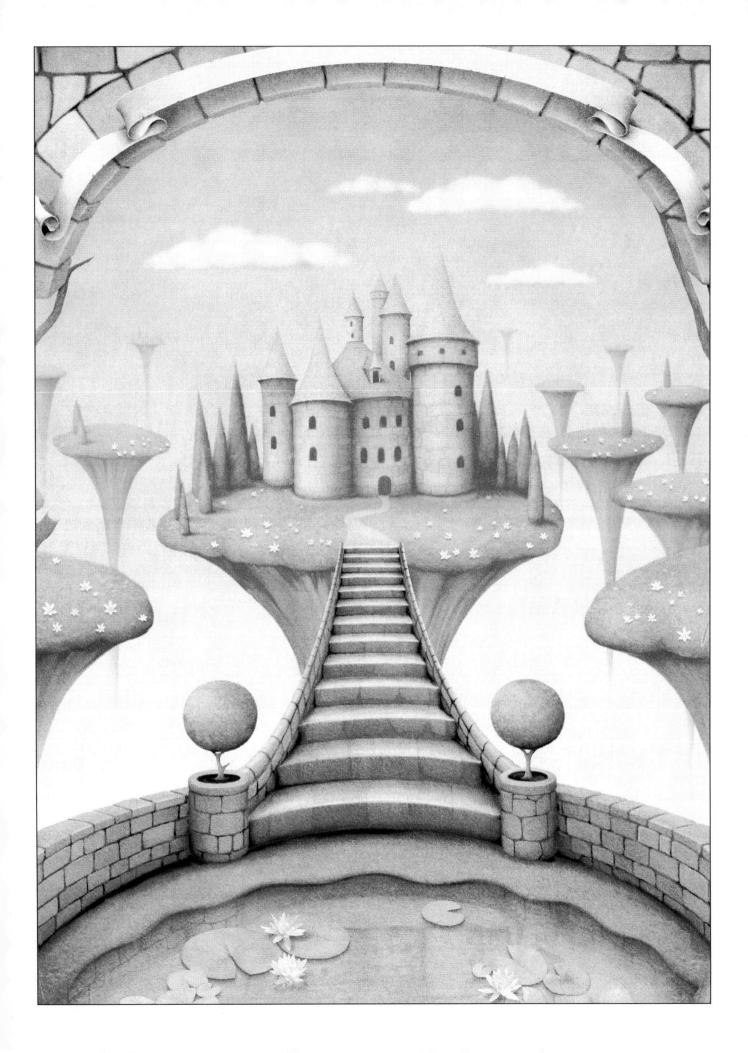

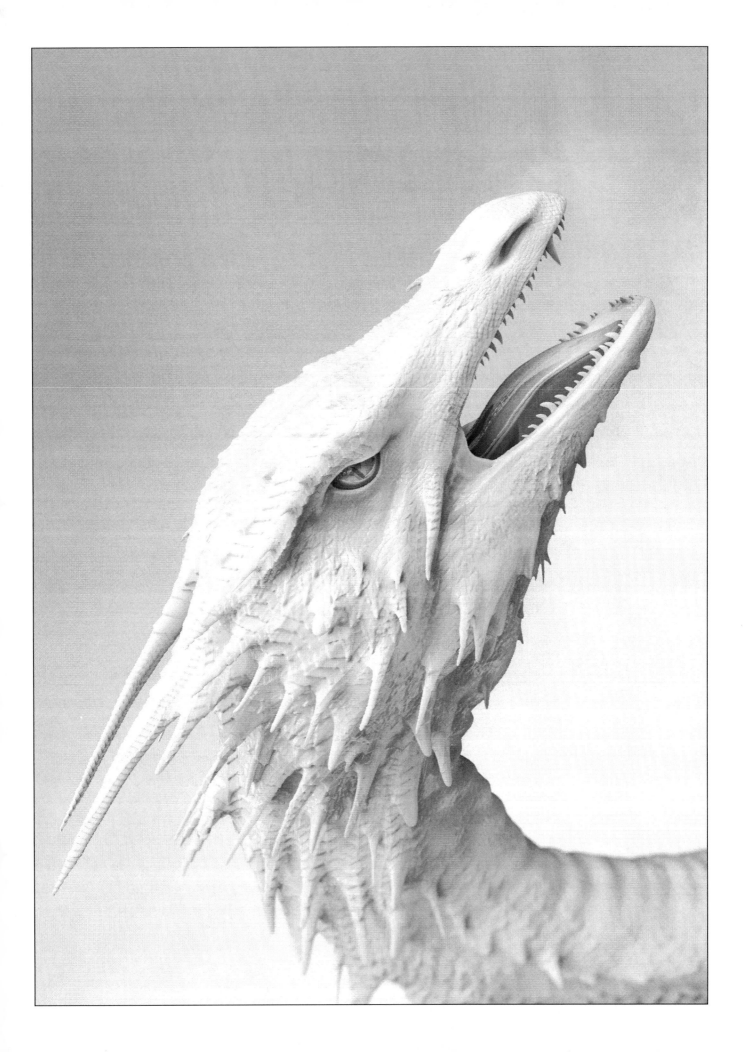

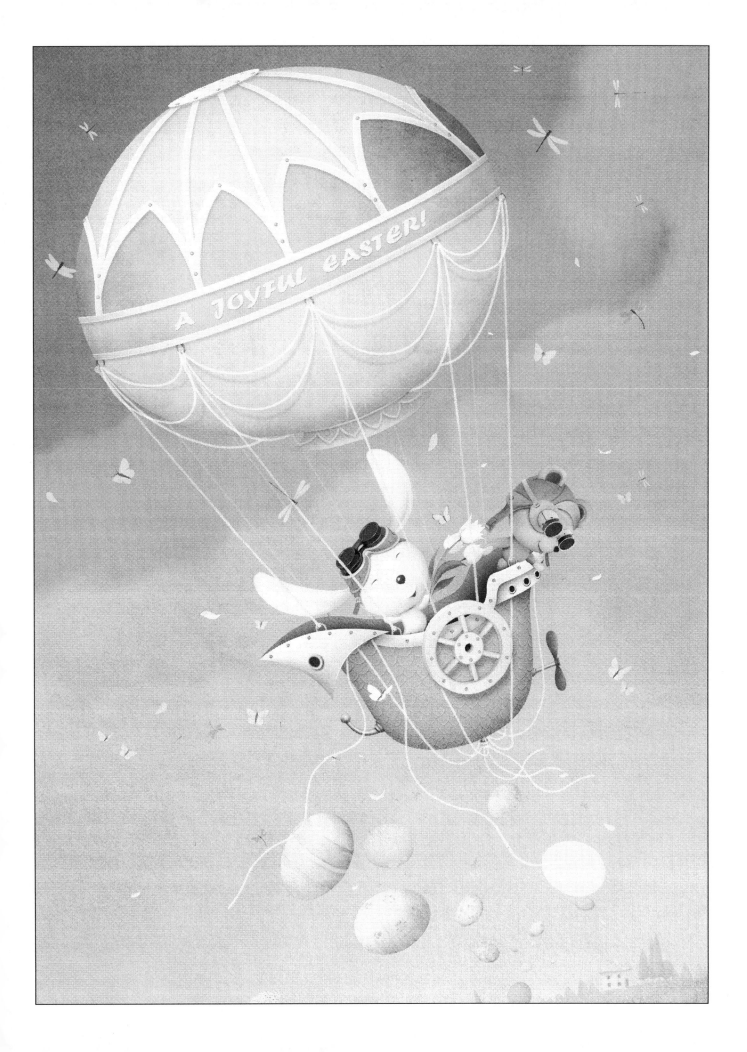

FREE DOWNLOAD

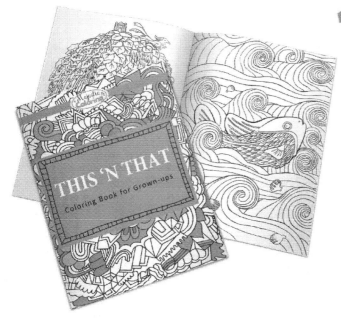

12 FUN DESIGNS FOR YOUR COLORING ENJOYMENT!

This 'n That Coloring Book for Grown-Ups is bundled up in one convenient PDF file to download and print at your leisure.

Sign up for our Majestic Coloring mailing list and get a free copy of **This 'n That Coloring Book for Grown-Ups**.

Click here to get started

http://majesticcoloring.com/thisnthat-free

Made in the USA
San Bernardino, CA
18 July 2016